Skira**M**ini**ART**books

D0770170

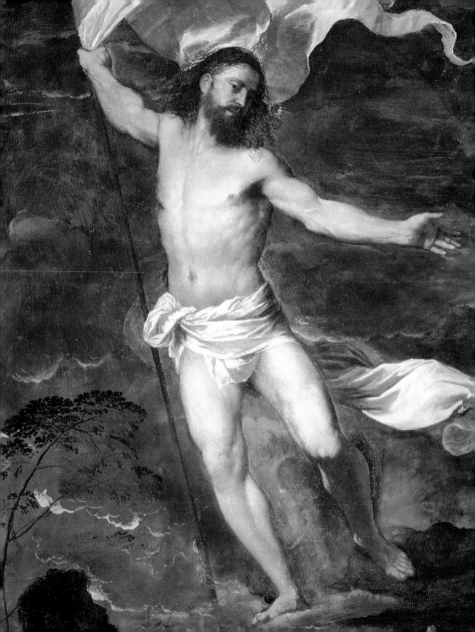

Cecilia Gibellini

TITIAN

SKIRA

Skira editore
SkiraMiniARTbooks

Editor
Eileen Romano

Design
Marcello Francone

Editorial Coordination
Giovanna Rocchi

Layout
Anna Cattaneo

Editing
Maria Conconi

Iconographical Research
Marta Tosi

Translation
Catherine Bolton for Scriptum,
Rome

First published in Italy in 2009
by Skira Editore S.p.A.
Palazzo Casati Stampa
via Torino 61
20123 Milano
Italy

www.skira.net

Printed and bound in Italy.
First edition

ISBN 978-88-572-0539-7

Front cover
Venus of Urbino (detail), 1538
Galleria degli Uffizi, Florence

Facing title page
Averoldi Polyptych.
The Resurrection of Christ
(detail), 1520–22
Santi Nazzaro e Celso, Brescia

On page 86
Self-portrait (detail), *circa* 1562
Staatliche Museen zu Berlin,
Gemäldegalerie, Berlin

Contents

7 Titian

33 Works

 Appendix

88 Catalogue of the Works

90 Timeline

92 Critical Anthology

95 Selected Bibliography

Titian

iziano Vecellio was born into a very old, eminent and well-to-do family in Pieve di Cadore, a town in the Dolomites situated at the edge of the Republic of Venice. The artist's date of birth is uncertain. According to most modern scholars, Titian was born between 1488 and 1490, an assumption based on the testimony offered by Ludovico Dolce in his *Dialogue on Painting* (1557), in which the author noted that when Titian frescoed the Fondaco dei Tedeschi in 1508 he was "not yet 20 years old". Yet the date cited by Dolce is unconvincing, as it is likely that – being Titian's friend – he lowered the artist's age to make him appear even more precocious.

Titian must thus have been born some time between 1480 and 1485, as suggested by Erwin Panofsky (1969), Charles Hope (1980) and Augusto Gentili (1990), who supported their theory not with documents, which are rather unreliable in this case, but through what they were able to glean by examining the painter's works, particularly his earliest ones. Among these, the small altarpiece now in Antwerp, *Pope Alexander VI Presenting Jacopo Pesaro to Saint Peter*, is of prime importance. The painting, celebrating the defeat of the Turks at Santa Maura in August 1502 at the hands of the Spanish, Venetian and papal fleets, the latter commanded by Jacopo Pesaro, has often been dated to 1508–12. In reality it must have been commissioned much earlier, in 1503, shortly after the battle it celebrates but before the death of Alexander VI, the Borgia pope who promoted this military undertaking, as the pontiff's demise in 1503 was promptly followed by a sort of *damnatio memoriae*. The chronological indication not only acknowledges the painting as Titian's first work, but also testifies to his precociousness: shortly after his arrival in Venice, at just 20 years of age he managed to win a commission denoting great personal and political prestige.

When the young Titian left Cadore for Venice in the late 1400s, the city on the lagoon was at the height of its splendour. At the threshold of the new century, Venice was one of the most populous cities in Europe, the undisputed mistress of maritime trade in the Mediterranean, and was simultaneously developing her dominion on the mainland. Venice's cultural life also underwent lively renewal during this period: the Cancelleria di San Marco and the School of Logic and Natural Philosophy of Rialto were vital centres of historical, literary, scientific and philosophical studies. With Aldus Manutius, Venice became the European capital of publishing and the driving force of the most sophisticated humanism. The city's singular tolerance and proud determination to be independent of the Holy See attracted intellectuals and writers who wanted to express their ideas freely, without ecclesiastical conditioning and control.

The Three Ages of Man
(detail), 1512–13
National Gallery
of Scotland, Edinburgh

From an artistic standpoint, in 1500 Leonardo da Vinci stayed briefly in Venice, and in 1505 and 1506 the German master Albrecht Dürer lived in the city. His works, characterized by harsh realism bordering on expressionism, had a decisive influence on Venice's figurative culture, which was already open to the input of Northern European art – Flemish and German – known through the widespread circulation of paintings and, above all, engravings. Titian was unquestionably familiar with these new pictorial trends from distant lands and his training was naturally influenced by the great masters who, at the turn of the 16th century, renewed the art and figurative culture of Venice: Vittore Carpaccio, Giovan Battista Cima da Conegliano, the young Lorenzo Lotto and Sebastiano Luciani, later called del Piombo, and – above all – the brothers Gentile and Giovanni Bellini, and Giorgione da Castelfranco.

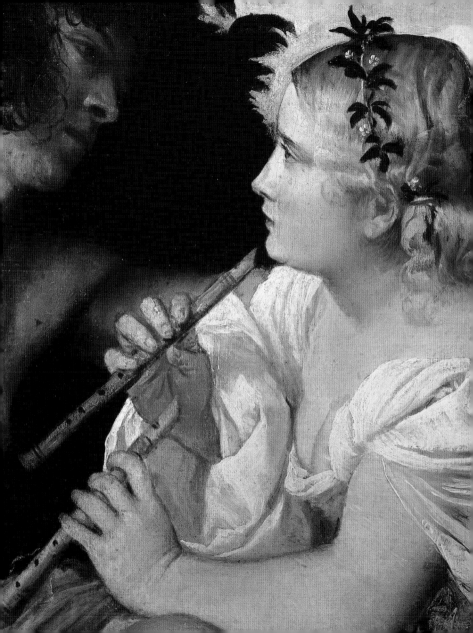

The accounts of the artist's childhood, which have an aura of legend about them, describe a young man who, in his home town of Pieve di Cadore, painted a Madonna "with the juice of flowers". The information from *Dialogue on Painting* is less fanciful, albeit not entirely exact, and Dolce tells us that following an initial apprenticeship at the *bottega* of the mosaicist Sebastiano Zuccato, Titian joined the workshop of Gentile Bellini and then that of the master's more "modern" brother Giovanni, later moving on to work with Giorgione. The linearity of this curriculum is nevertheless contradicted by an analysis of Titian's earliest works, which reveals that the artist had far more models and demonstrates, in particular, that his debt to Giorgione must largely be reassessed with respect to previous beliefs.

The Antwerp altarpiece demonstrates Titian's progressive shift towards the style of different masters: the figure of Pope Alexander VI, painted first, was influenced by the dry, graphic style of Gentile Bellini; the lines and soft hues of Saint Peter, executed subsequently, instead approach the figures painted by Giovanni Bellini in his masterpieces of the early 16th century; the vigorous realism of the splendid portrait of Pesaro, completed last, unquestionably draws on Flemish and German art. At this point in time, however, no references to Giorgione can be noted. The sublime results achieved by the master from Castelfranco in the definition of atmospheric elements and the fusion of colour have led modern critics to credit him with all the novelties and innovations that emerged in Venetian painting in the first decade of the 16th century. Consequently, Titian (as well as Sebastiano del Piombo) has long been considered a "creation" of Giorgione. With regard to many works that are undocumented and difficult to attribute, the tradition of Titian's apprenticeship at Giorgione's workshop spawned the theory that,

upon his death in 1510, Titian took up his master's legacy, completing his unfinished paintings (including *Christ and the Rogue* at the Scuola di San Rocco, *The Concert* at the Palazzo Pitti and *The Pastoral Concert* at the Louvre). Aside from iconological and stylistic considerations, which lead to attributing these works to the young Titian, this simplistic assumption goes against coeval sources, none of which indicate that Giorgione had a workshop, school or pupils. Indeed, he worked in the private realm, establishing relations with elite humanistic circles; he was not involved in major public, ecclesiastical or civic commissions.

Following pages
The Pastoral Concert
(detail), 1509–10
Musée du Louvre, Paris

The young Titian instead took an entirely different approach. He too came to Venice from a small provincial town, but unlike Giorgione he was willing to proffer his talent to cater to the needs of Venetian patrons, from highly reserved humanistic circles to the official representatives of political and religious power. With the "entrepreneurial" shrewdness that would mark his entire artistic career, Titian promptly managed to garner prestigious and varied commissions.

As already noted, many of the paintings traditionally indicated as having been commenced by Giorgione and completed by Titian can instead be attributed entirely to the latter. One exception is the famous *Sleeping Venus* in Dresden, painted by Giorgione in 1507 for the marriage of Gerolamo Marcello and Morosina Pisani. The patron who commissioned the work must have found Giorgione's image of the goddess of love, distinguished by a demure and idealized beauty, inappropriate for the occasion and its placement in his bedchamber. Consequently, upon Giorgione's death in 1510 Titian was asked to alter the painting, adding details that accentuate the image's erotic appearance.

11

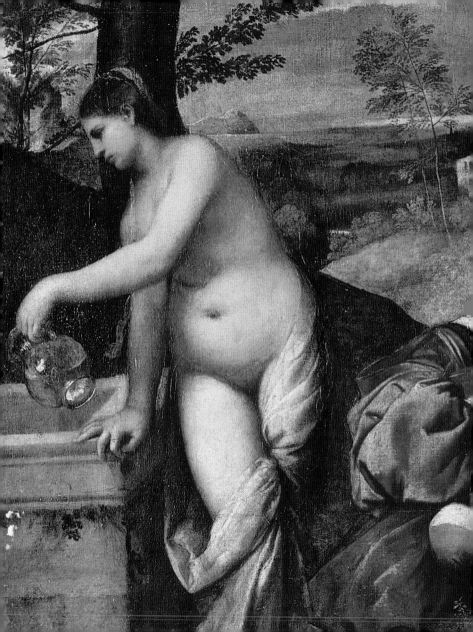

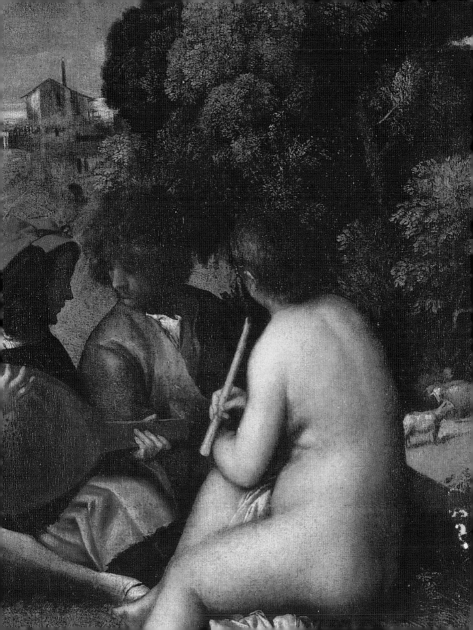

In portraiture as well, Titian rapidly moved away from Giorgionesque models. Whereas Giorgione's portraits are busts, separated from the observer by a parapet, Titian eliminates any partition, establishing direct contact between the viewer and the persons portrayed, represented from the knees or waist up: they are no longer immobile, dreamy figures but real individuals whose sentiments and emotions are captured with extraordinary insight and vitality.

Titian's first official commission was for the frescoes executed in 1507–08 on the inland façade of the Fondaco dei Tedeschi, an inn and marketplace for Northern European merchants but owned by the Venetian Republic and reconstructed after a fire that broke out in 1505. These decorations deteriorated rapidly. Only fragments have survived, the most important of which – known to us thanks also to the invaluable etchings that Antonio Maria Zanetti made in the 18th century. Their overall programme is difficult to reconstruct: Titian's frescoes probably had a political subject. The female figure that appears in a fragment with her sword raised to an imperial soldier can be construed as an allegory of Venice, of the political power and the divine protection enjoyed by the city in the period in which it was threatened by the League of Cambrai, which included the German emperor Maximilian. Titian was thus entrusted with the task of inspiring respect for *La Serenissima* among the merchants staying at the Fondaco, Germans like the sovereign who was threatening Venice's power during this period.

The Saint Mark altarpiece, which Titian painted around 1510 for the Venetian church of Santo Spirito in Isola and that is now at Santa Maria della Salute, also bore precise political messages. The work, painted as a votive offering during a terrible plague epidemic, was probably

14

commissioned from Titian by the Republic, as suggested by the pre-eminence of the figure of Saint Mark. Here as well, Titian thus interprets the self-celebration of Venice and its political and ideological claims.

Similar observations can be made regarding the three frescoes executed in Padua at the Scuola di Sant'Antonio between April and December 1511. The subjects – miraculous episodes in which St. Anthony reconciles feuding families – also serve the purpose of celebrating the pacification between Venice and Padua. In the Paduan work, Titian deployed a figurative culture that is already mature and autonomous, as we can see from his cultured allusions to ancient statuary, compositional solutions and brilliant chromatic texture. By winning highly prestigious public commissions, the painter thus rose to a leading position on the Venetian art scene. As he was completing the Paduan frescoes, he was also preparing the drawing for the monumental woodcut of the *Triumph of Christ*, courageously trying his hand at the medium in which Andrea Mantegna, Albrecht Dürer and Marcantonio Raimondi also worked. The *Triumph* represents the victory of the Christian faith – in a procession of magnificent visual impact – but it is also an allegorical celebration of the reconciliation between Venice and the Church of Rome. The work is also linked stylistically with the Roman culture, embracing precociously the monumentality and plasticism of the inventions of Raphael and Michelangelo, known in Venice thanks to Fra' Bartolomeo's sojourn in 1508 and, above all, drawings and engravings after their works.

As he gradually took on the role of official painter of the Venetian Republic, Titian also became closer to the humanistic circles active in the city in the early 16th century, composed of patricians and wealthy merchants. Titian took the literary, philo-

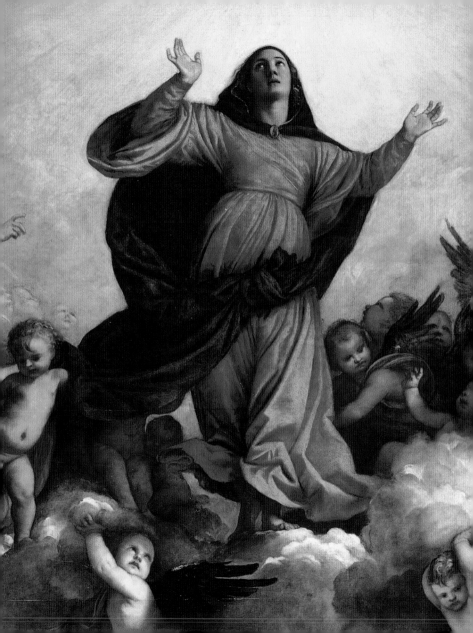

sophical and musical ideas developed by this elite and turned them into uniquely private works whose leitmotif is the relationship between love and music, at the heart of the contemporary philosophical and musical theories of Pietro Bembo, Mario Equicola and Leone Ebreo, based on a Pythagorean-Neoplatonic conception. Musical harmony symbolizes harmony in love, viewed not as carnal passion but as Bembo's "good love", which coincides with the desire for "divine and immortal" beauty and is associated with "noble" stringed instruments, the symbol of a cultured, refined and urbane music whose harmony is nevertheless often threatened by the intrusion of disorder and carnal instincts. This was the theme of the famous *Pastoral Concert* now at the Louvre, painted in 1509–10, in which the perfect accord between the lute played by an elegant young man and the flute held by a naked Muse is disrupted by a coarse shepherd. This motif is also evident in Edinburgh's *Three Ages of Man* (1512–13), and complex allegorical meanings are present in the painting known as *Sacred and Profane Love* (1514–15), the allusive celebration of an important wedding: that of Niccolò Aurelio and Laura Bagarotto. Titian again tackled the subject of love and music about ten years later, when Alfonso I, Duke of Ferrara, commissioned four paintings for his private *studiolo* at the Este castle, known as the Alabaster Chamber, which has not survived. The duke wanted his chamber to be decorated with a series of paintings depicting bacchanals, as Dionysian episodes were viewed as a way to evade the troubles of the world and of history. Thus we find Titian painting the *Offering to Venus* and the *Bacchanal on Andros*, now at the Prado, and *Bacchus and Ariadne*, now in London; he also modified the *Feast of the Gods*, executed by Giovanni Bellini in 1514, re-

Assumption of the Virgin (detail), 1516–18 Santa Maria Gloriosa dei Frari, Venice

17

painting the landscape and some of the figures in order to match the painting stylistically to his own œuvre. With these canvases, Titian fluidly interpreted the mythological themes that the court humanists established as part of a specific programme and he created compositions in which moralizing elements were juxtaposed with a sense of Dionysian inebriation through the dynamism of the figures and a dazzling palette.

The altarpiece of the *Assumption of the Virgin*, commissioned from Titian for the high altar in the Franciscan church of Santa Maria Gloriosa dei Frari in 1516 (the year Giovanni Bellini died), confirmed the artist's success in the arena of major religious works. After patiently establishing a network of public and private relations, with this work Titian began to paint the large altarpieces that would come to represent a substantial part of his production.

The *Assumption*, installed in a monumental marble shrine during a solemn ceremony in May 1518, promptly aroused sensational reactions in his contemporaries because of its iconographic and stylistic innovation. In its magnificent conception, Titian's altarpiece alluded to the coeval Tuscan and Roman figurative culture, enriched by an uncommon use of colour that accentuated the dramatic values of the scene, giving it extraordinary unity. Immediately after the *Assumption* was installed, Jacopo Pesaro, Bishop of Paphos asked Titian to paint another altarpiece for the same church. The Pesaro altarpiece celebrates its patron, evoking the now-distant victory of Santa Maura, and his dynasty, through the splendid gallery of portraits in the lower register. Furthermore, through a series of symbolic elements it alludes to the cult of the Immaculate Conception, promoted by the Franciscans installed in the Venetian church. The painting was devised with a completely innovative spatial conception, set dynamically on diagonal and ascending lines.

18

The same deft fusion of theological and liturgical allusions, along with elements whose aim was the personal and dynastic celebration of their patrons, characterize other altarpieces painted by Titian in the 1520s. One of them is the altarpiece of the *Madonna in Glory with Saints Francis and Biagio with the Donor Alvise Gozzi*, which the Ragusan merchant portrayed in the painting commissioned in 1520 for the church of San Francesco in Ancona; it is now preserved in this city. In 1520 Titian also painted the altarpiece for the Brescian church of Santi Nazzaro e Celso, commissioned by Altobello Averoldi, Apostolic Legate in Venice. Although he was conditioned by the archaic polyptych form, unquestionably requested by the patron, the painter nevertheless created a unitary and utterly modern work through his reference to ancient and Michelangelesque sculptures (the Risen Christ in the middle takes up the famous Greek statue of *Laocoön*, whereas the figure of Saint Sebastian in the right panel was inspired by Michelangelo's *Prisoners*) and, above all, the dynamic use of light, of fundamental importance for the future developments of the Brescian school of painting.

The altarpiece depicting the *Death of Saint Peter Martyr* has unfortunately been destroyed in a fire in 1867. Titian painted the work for the altar of the school named after the saint in the Dominicans' prestigious Venetian church, Santi Giovanni e Paolo, which housed the tombs of the Republic's most powerful figures, first and foremost, the doges. The painting depicted the dramatic scene of the preacher's martyrdom, and it was described enthusiastically by the artist's contemporaries. The work testified to Titian's interest in the relationship between figure and landscape, which is also quite evident in coeval religious subjects such as *The Aldobrandini Madonna* in London, the *Adoration of the Shepherds* at the Palazzo Pitti and the *Madonna of the Rabbit* at the Louvre.

19

I n the same period in which he painted the large altarpieces, Titian became the official painter of the Venetian Republic, thanks also to the patronage of Doge Andrea Gritti, elected in 1523. In 1509 Gritti had triumphantly reconquered Padua and once he became doge he implemented a policy of cultural promotion to launch the image of Venice as the heir of both eastern Rome – Constantinople – captured by the Turks in 1453 and of the Rome of the popes, devastated by the sack of the Lansquenets in 1527. The leading figures in this *renovatio urbis Venetiarum* project were Titian and two Tuscans who

Bacchus and Ariadne
(detail), 1522–23
The National Gallery,
London

arrived in the capital of the Republic the year Rome was sacked: the great writer and pamphleteer Pietro Aretino and the architect Jacopo Sansovino. The three artists immediately established a solid and fruitful rapport, forming a sort of "artistic triumvirate" that was destined to control the entire cultural life of the Venetian Republic in the mid-16th century. Sansovino's great urbanistic reorganization of the Piazza and Piazzetta di San Marco, with the creation of an unbroken series of classical-style architectures, from the Zecca to the Torre dell'Orologio, confirmed Titian's ideas and stimulated him to develop his own elevated language. References to Sansovino can clearly be perceived in the magnificent classicistic architecture framing the scene of the *Presentation of the Virgin in the Temple*, painted by Titian between 1534 and 1538 for the Sala dell'Albergo of the Scuola Grande di Santa Maria della Carità (now at the Gallerie dell'Accademia). In his paintings Titian interpreted Gritti's heroic and imperialistic ideology, effectively paralleling Sansovino's approach to his architectural works. This explains why Gritti was so fond of him, as demonstrated by the fact that

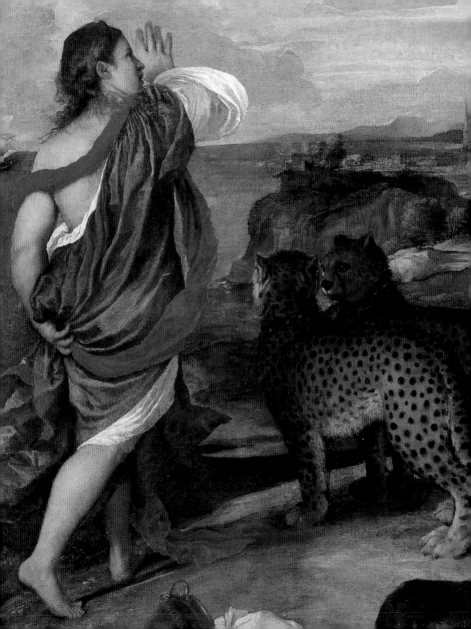

he entrusted Titian with important works for the Doge's Palace: the monumental fresco of *Saint Christopher* painted in 1523 on the wall over the staircase to the doge's apartment; his own official portrait for the *Sala del Maggior Consiglio* and the votive painting for the *Sala del Collegio*, both destroyed in the fire that devastated the palace in 1577; the frescoes for a chapel inside the palace, also lost; and the battle scene in the *Sala del Maggior Consiglio*, which Titian had already offered to paint in 1513 to replace Guariento's *Battle of Spoleto* but that, as proposed by Pallucchini (1969), was probably supposed to represent – under Gritti's auspices – the Venetians' more recent victory (1508) over the imperial troops near Cadore. It too was destroyed in a fire in 1577, but an old copy preserved at the Uffizi, as well as valuable preparatory drawings and engravings, demonstrate what the composition must have been like. A few years after Gritti's death in 1538, Titian also painted his splendid portrait, now in Washington, which handed down to posterity a heroic and vigorous image of the doge.

Nevertheless, Titian's most important and influential relationship was the one with Pietro Aretino, whose writings and letters – addressed to all the most powerful figures in Europe – promoted the success of his painter friend. In turn, however, Pietro also benefited greatly from Titian's growing reputation. One of the most eloquent testimonials of their association is unquestionably the splendid portrait that Titian painted of Pietro around 1545, now at the Palazzo Pitti.

The praise heaped on Titian by his friend Pietro certainly bolstered his fame and the demand for his paintings, particularly his portraits. The one painted of Emperor Charles V in 1533 brought the painter prestige and privileges that established his renown in Italy and across Europe, paving the way for a series of commissions of

prime importance. Of the most significant portraits painted by Titian starting in the 1530s, some of the most noteworthy depicted the leaders of the era, from Doge Francesco Venier to the French king Francis I, as well as John Frederick, Elector of Saxony, and the Marquis of Mantua Federico II Gonzaga, the Spanish sovereigns (Charles V, Isabella of Portugal and Philip II), who would enjoy a privileged relationship with him from then on, and the politicians, officials and soldiers tied to them.

Titian's works for the dukes of Urbino are very significant: the splendid portraits executed in 1536–37 of the *condottiero* Francesco Maria della Rovere and his wife Eleonora Gonzaga, now at the Uffizi; and the famous *Venus of Urbino*, commissioned by Francesco Maria's son Guidobaldo II della Rovere. Completed in 1538, it is a work that fully reveals the divide between the mature painter and the illustrious Giorgionesque model of the Dresden *Venus*, executed in 1507 and partially repainted by Titian in 1510. Titian juxtaposes the ideal beauty of that Venus, serenely contemplated as she slumbers in the peacefulness of nature, with the sensual image of a real woman who, stretched out on an unmade bed and with her hair flowing over her shoulders, gazes seductively at the observer. She is surrounded by her traditional attributes (she has roses in her right hand and a vase of myrtle is set on the windowsill), but is also accompanied by realistic details that create an atmosphere of coquettish intimacy (the little dog curled up on the bed and the handmaidens pulling rich garments from the wedding chest). The painting, which underscores the importance of eroticism in marriage, was commissioned by Guidobaldo: for political reasons he married Giulia Varano da Camerino in 1534 – she was just ten at the time – and the work was probably intended to entice his bride, an

adolescent by then, into an amorous union with her husband through an appropriate and culturally prestigious model.

The works painted by Titian between the late 1530s and the mid-1540s are characterized by the study of form and attention to plastic values and draughtsmanship, which reflect the experiences of the Tuscan and Roman Mannerists. In reality, Titian had probed the refined and "modern" language developed in central Italy much earlier, thanks to his familiarity with Pordenone's Michelangelesque dynamism, engravings after the works of Michelangelo and Raphael, the Mantuan architectures of Giulio Romano, active at the Gonzaga court as of 1524, the reflections of Sebastiano Serlio and the classic-style buildings of Sansovino, and the classical and modern works of art he discovered while staying at aristocratic courts. Titian's Mannerism thus cannot be considered "accidental, a watershed or a crisis, nor did it depend solely on direct opportunities in Venice: it was instead the result of experimenting with the experiences and languages of current trends, commenced quite early and practised regularly, and the transfer of those experiences and languages, as instruments of cultural renewal and expressive enrichment, in the consolidated practice of the Venetian pictorial tradition" (Gentili 1990). Nevertheless, it must be noted that he also had direct contact with Tuscan and Roman painters through the arrival in Venice of Tuscan artists such as Francesco Salviati and his pupil Giuseppe Porta in 1539, and of Giorgio Vasari in 1541; furthermore, Titian was in Rome in 1545–46.

When the artists of central Italy reached Venice, Titian was again the sole leader in Venetian painting, as Pordenone died in 1539, Loren-

Portrait of Gabriele Tadino (detail), 1538
Cassa di Risparmio di Ferrara, Ferrara

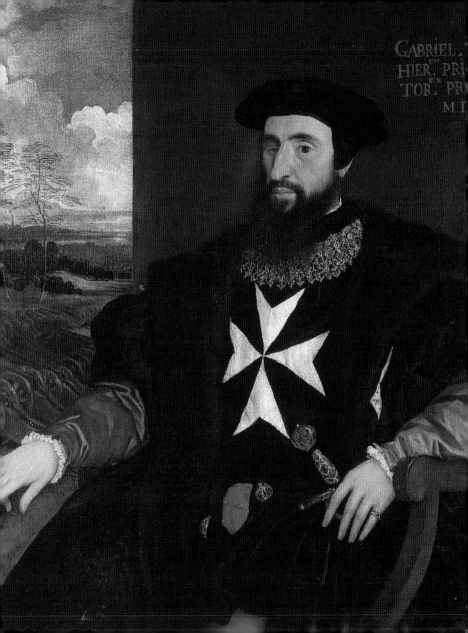

GABRIEL
HIER. PRI
TOR. PRI
M D

zo Lotto was less and less present, and Girolamo Savoldo continued his research in increasing isolation.

Titian's finest canvases from this period show a synthesis of programmatic formal and "academic" research, on the one hand, and rich luminist and chromatic orchestration on the other. Indeed, through them, in the debate on art and aesthetics conducted in Venice during this period Titian launched a proud challenge, providing a series of exemplary demonstrations of the possibility of merging Tuscan "draughtsmanship" with Venetian "colouring". Titian's most famous works from those years can be interpreted in these terms: the altarpiece of *Saint John the Baptist* (*circa* 1540), painted for the church of Santa Maria Maggiore and now at the Accademia; the magniloquent scene of *The Marquis of Vasto Addressing his Troops* (1540–41), now at the Prado; and the first version of *Christ Crowned with Thorns*, painted in 1542–44 for the Milanese church of Santa Maria delle Grazie and now at the Louvre, in which powerful figures portrayed in Michelangelesque poses are set in an architecture resembling Giulio Romano's Mantuan creations.

In the meantime, when in 1542 he painted the portrait of twelve-year-old Ranuccio Farnese, the son of the head of the papal army, Pier Luigi Farnese, and the grandson of Pope Paul III, Titian entered into the good graces of this powerful family, which then commissioned important paintings from him and encouraged him to move to Rome. Titian left Venice in September 1545 and arrived in the capital on 9 October 1545. Welcomed to the papal court with great honour, he was accompanied by Vasari and Sebastiano del Piombo to visit the monuments of the Eternal City and met Michelangelo. Despite his festive welcome, however, the city's artistic circles did not grasp the sensual naturalism and chromatic freedom of his paintings. For example, Vasari (1568) men-

tioned Michelangelo's reservations about the *Danae*, which Titian completed in 1546 at the Belvedere for Cardinal Alessandro Farnese.

This substantial incomprehension explains why Titian was employed above all as a portraitist during his Roman sojourn, first and foremost by Pope Paul III, who had himself depicted with his grandsons Alessandro and Ottavio Farnese. In that canvas, Titian reveals how far removed he was from the gelid and controlled works of the central Italian Mannerists, transforming the fixed and rigid models of "State portraits" into "action portraits" that were essentially narrative in nature. Because of the truthfulness of the representation and the air of subtle disquiet that permeates the scene, the three illustrious figures preferred individual portraits to this one, i.e. works with a more "official" tenor that were less psychologically engaging.

The solemn bestowal of Roman citizenship on 19 March 1546 concluded Titian's stay in Rome. After a brief visit to Florence, he returned to Venice, where he resumed the works he had left unfinished, adopting a style that, while enriched by his Roman experiences, was nevertheless driven by ever-new research and experimentation in light and colour.

In the company of his favourite son Orazio and of Lamberto Sustris, Titian left Venice again in 1548 to go to Augusta, where Charles V convened the princes, dukes, counts and Electors of the Empire, divided by the Lutheran Reformation. As soon as he reached the Swabian city, he promptly set to work on a large number of portraits of the important political figures united there, notably that of Emperor Charles V on horseback. During the same period, Titian painted a decidedly erotic subject for the emperor's son, Philip II: *Venus with the Organist*, now at the Prado, which was replicated in at least two ver-

27

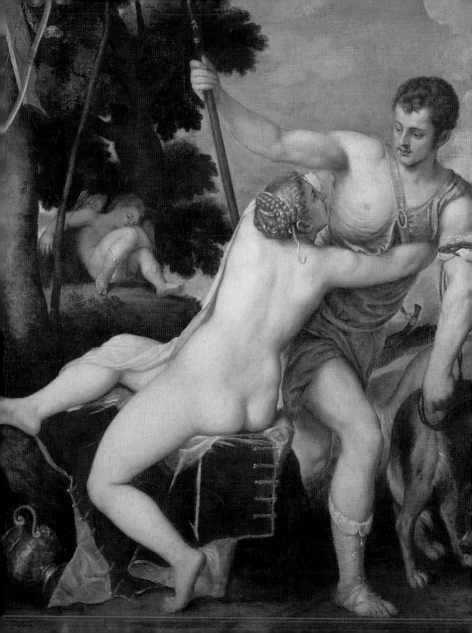

sions (one also at the Prado and the other in Berlin). The celebration of the patron also emerges in this painting, as the organist turning to admire the voluptuous naked body of the goddess seems to have Philip's facial features (Gentili).

W hen he returned to Venice from Augusta at the end of October 1548, the artist found himself working alongside the young Jacopo Tintoretto, who had finished his first prestigious public work, the *Miracle of Saint Mark*, for the Scuola Grande di San Marco (1548, now at the Accademia) during Titian's absence. At the same time, Paolo Veronese claimed his monopoly on the decoration of the villas of the mainland, an area in which Titian, a painter with an "avowed urban vocation", had no interest (Gentili 1990). Most of the works that Titian executed in Venice during this period were destined for sites that were essentially of modest or little political-ecclesiastic importance.

Venus and Adonis
(detail), 1553–54
Museo Nacional del Prado,
Madrid

As of the 1550s, we find that Titian was progressively absorbed by the commissions of Charles V and then Philip II of Spain, and it was for his Iberian patrons that the artist completed the masterpieces of his old age: works with both religious and mythological meanings, in which he developed a style ahead of its time, one that was new, terse and "impressionistic".

The patronage of Philip II is tied in particular to the mythological canvases painted by Titian between 1554 and 1576, the year he died. More than three decades separate these final "poesies" from the works with a similar subject painted in his youth. The ebullient celebration of the joyous vitality of the classical world, evident in the festive and

29

dazzlingly colourful celebrations of the second and third decades of the century, is replaced by poignant and even tragic meditations on the violence and cruelty of ancient fables. Mythological tales with dramatic endings are represented in this way: *Venus and Adonis* (1554), *Diana and Actaeon* (1556–59), *Diana and Callisto* (1556–59).

The three paintings underscore the negative significance of the hunt, the metaphor for human life, ever wandering and subject to the capriciousness of happenstance and the cruelty of the gods. Even when Titian represents stories with a happy ending, what he emphasizes is the dramatic moment in which the victims are struck by divine cruelty, as in the *Rape of Europa* (1559–62) and in *Perseus and Andromeda* 1562–63). Titian's pessimism in depicting ancient fables, to which he had looked hopefully in the years of his youthful Neoplatonism, culminates with his last two masterpieces, painted shortly before his death without a specific patron in mind: the scene of the *Death of Actaeon* and the *Flaying of Marsyas*. According to Gentili's penetrating interpretation of the painting, Titian wanted to represent the end of the natural and primitive world embodied by Marsyas and the advent of civilization and rational harmony represented by Apollo. The painter did not view this epochal change with the optimism of his early years, however, but with a sense of melancholy that is confirmed by the figure of King Midas, who mournfully watches the scene. The face of the king, a man from a defeated civilization, has been interpreted as Titian's self-portrait.

I t is no accident that in the last "poesies", and in the works with allegorical and religious subjects painted in his final years, Titian's style achieved the most astonishing expressive and pictorial freedom. The technique that characterizes Titian's last works interprets

and accentuates the gloomy pessimism and drama of the scenes they portray: his palette is darker and more subdued, with the gilded and burnished hues of ochre and brown, yet closer inspection reveals countless nuances and sudden glimmers of light. Draughtsmanship is virtually abandoned and colour is applied to the canvas with fast, vibrant brushstrokes, thick and impastoed. Many details are simply outlined with rapid brushstrokes or even produced with his fingers. There are numerous masterpieces from his final years that allow us to appreciate this revolutionary pictorial technique, generally misunderstood by his peers and reassessed only recently: the Munich *Christ Crowned with Thorns*, the Hermitage's *Saint Sebastian*, the Vienna version of the violent scene of *Tarquin and Lucretia*, and Titian's pictorial testament, the *Pietà*, now at the Gallerie dell'Accademia, in which Titian portrayed himself as the old man kneeling before the livid body of the dead Christ.

He was killed by the plague shortly thereafter, on 27 August 1576. A special provision spared him a mass grave but, given the circumstances, he was buried following a hasty ceremony. Titian left neither a *bottega* nor a school: he preferred to rely on collaborators who did not have a personal style, and masters such as Tintoretto, Paris Bordone and El Greco frequented his workshop only briefly. Nevertheless, his lesson was embraced and exploited not only by the Venetian artists of the 16th and 17th centuries, but by all the great colourists of European painting, from Annibale Carracci to Rubens, Caravaggio, Van Dyck, Rembrandt, Velázquez, Delacroix and the French Impressionists, who found the precedents for their revolutionary research in Titian's "chromatic alchemy".

Works

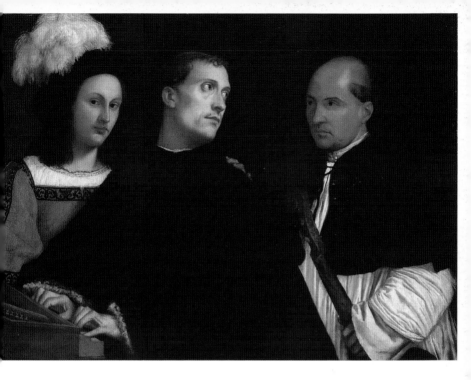

1. *The Concert*, 1507–08

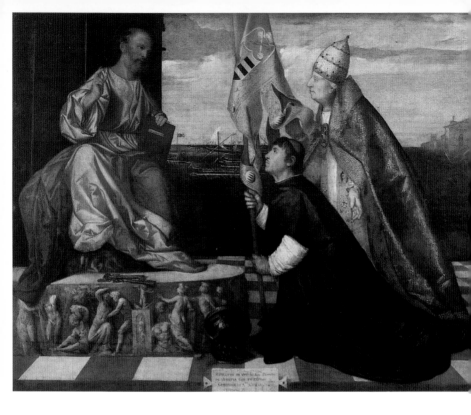

2. *Pope Alexander VI Presenting Jacopo Pesaro to Saint Peter*, 1503–06

3. *Saint Mark Enthroned with Saints Cosmas, Damian, Rock and Sebastian*, 1510

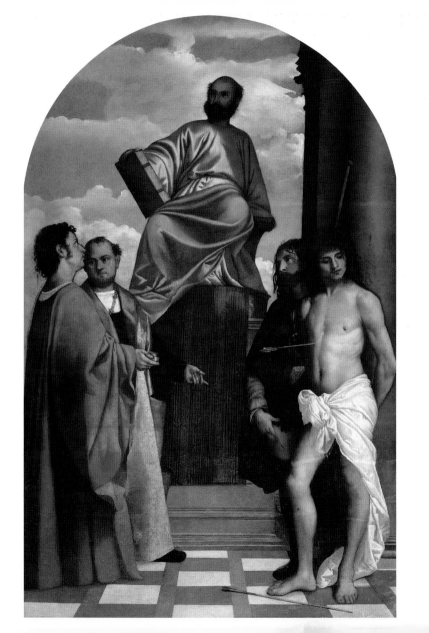

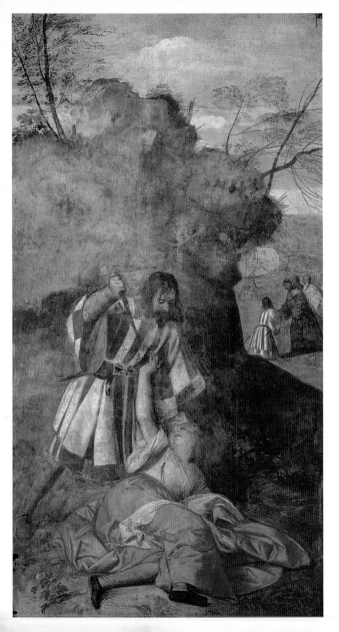

4. *The Miracle of the Jealous Husband*, 1511

5. *The Miracle of the Healed Foot*, 1511

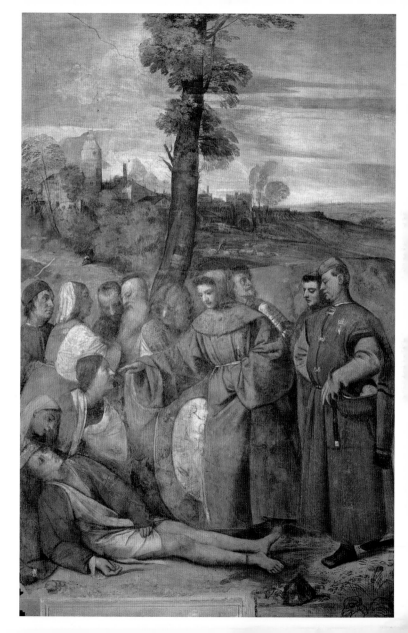

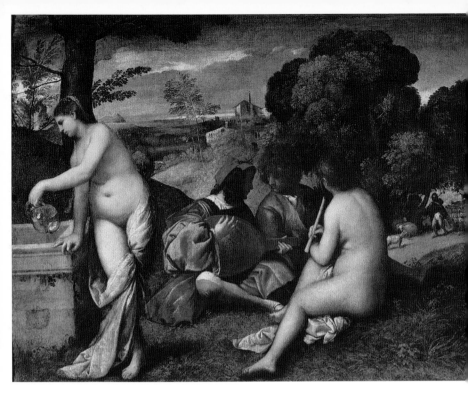

38

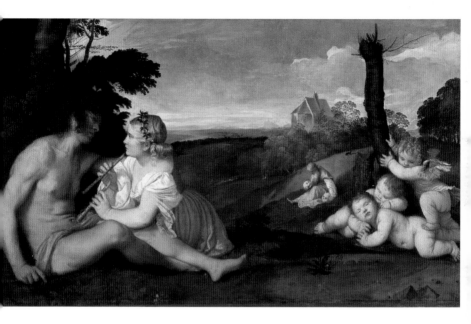

6. *The Pastoral Concert,*
1509–10

7. *The Three Ages of Man,*
1512–13

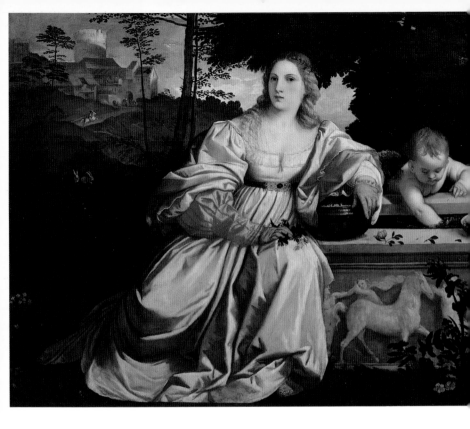

8. *Sacred and Profane
Love*, 1514–15

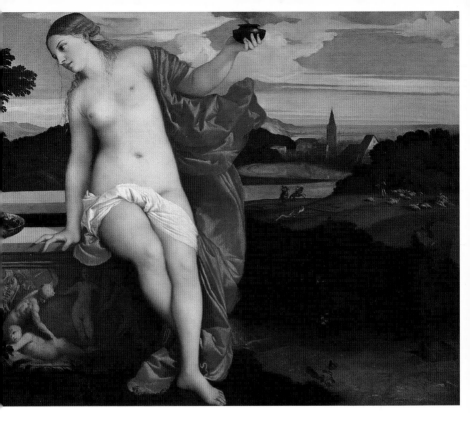

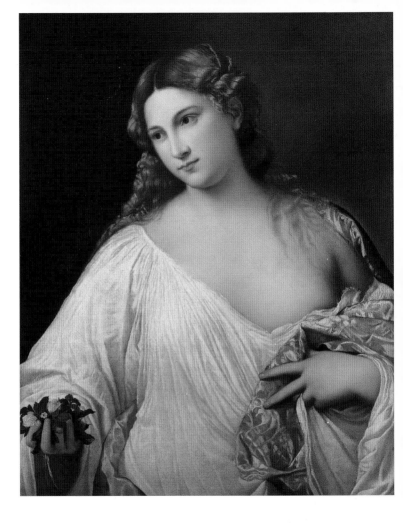

8a. *Sacred and Profane
Love* (detail), 1514–15

9. *Flora, circa* 1515

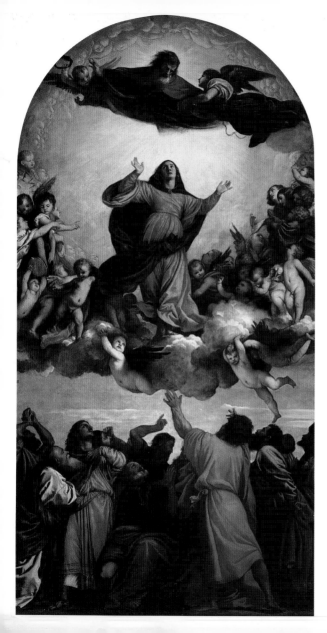

10. *Assumption of the Virgin*, 1516–18

11. *Pesaro Altarpiece*, 1518–26

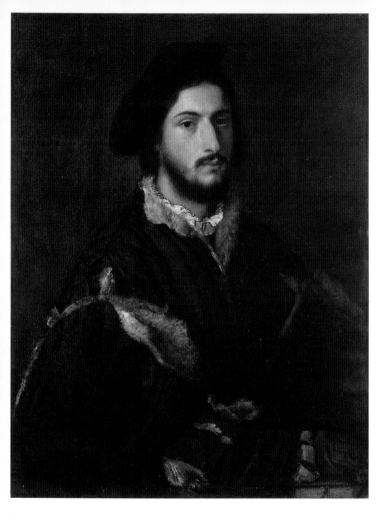

12. *Portrait of a
Gentleman* (*Tommaso or
Vincenzo Mosti*), 1520 (?)

13. *Man with a Glove*,
1520–23

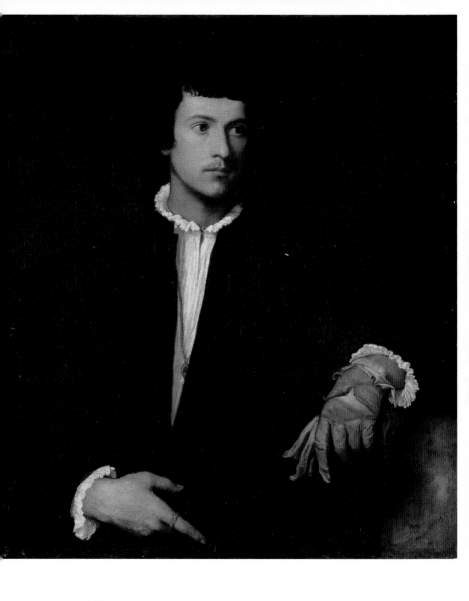

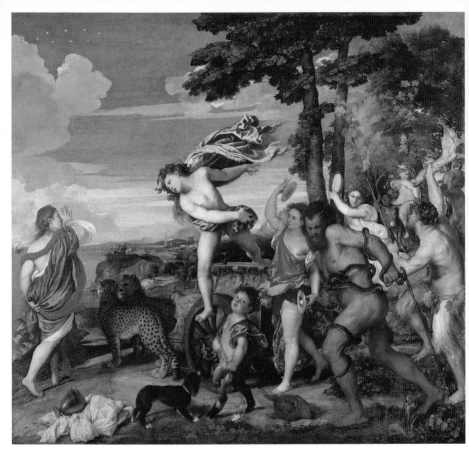

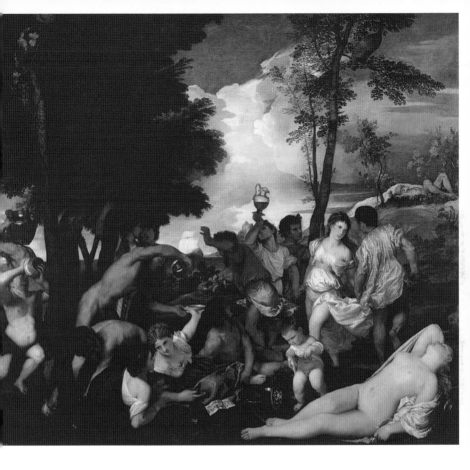

14. *Bacchus and Ariadne,*
1522–23

15. *Bacchanal on Andros,*
1523–24

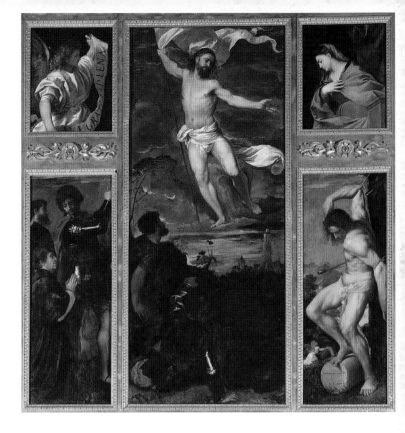

16. *Averoldi Polyptych*
(detail and entire work),
1520–22

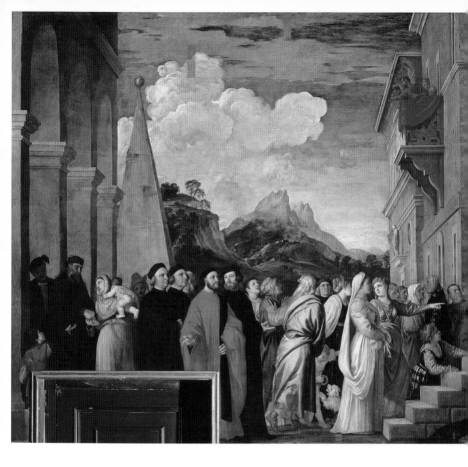

Following pages
18. *Portrait of Francesco Maria della Rovere,* 1536–37

17. *Presentation of the Virgin in the Temple,* 1534–38

19. *Portrait of Eleonora Gonzaga della Rovere,* 1536–37

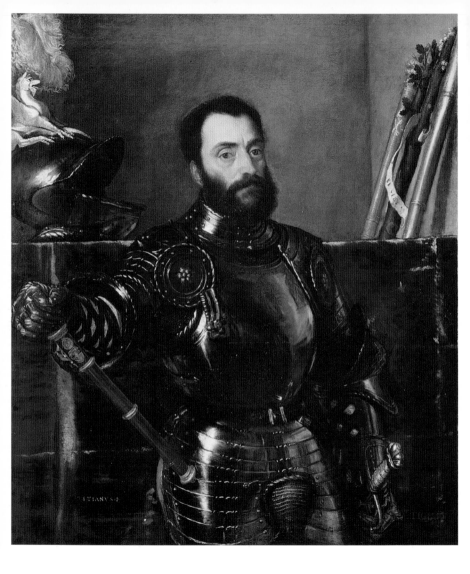

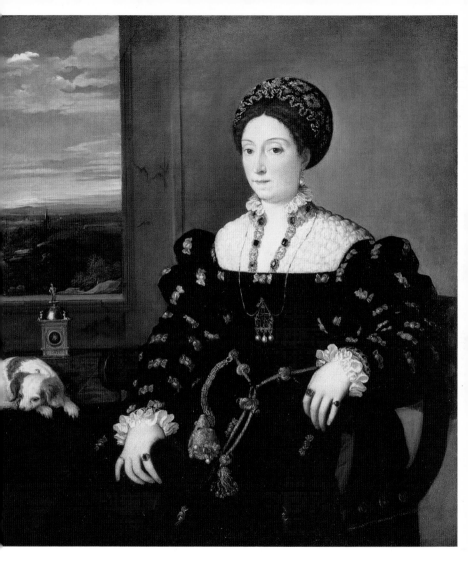

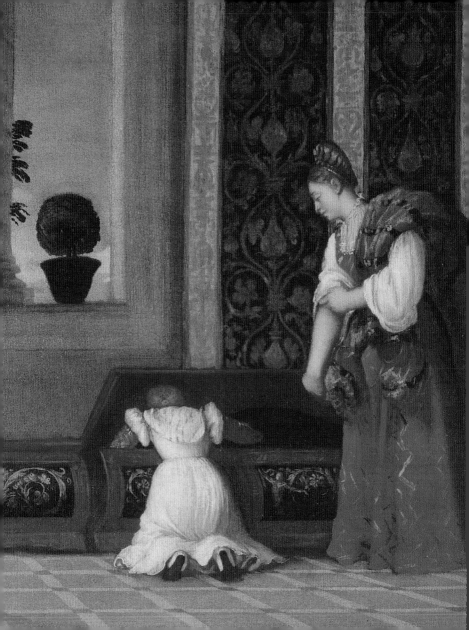

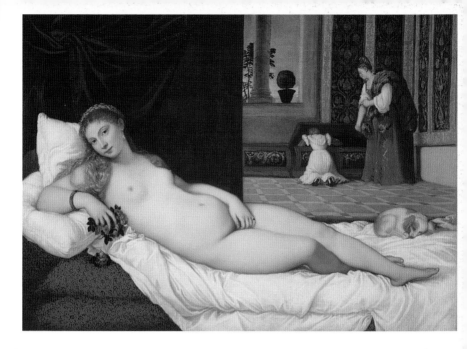

20. *Venus of Urbino*
(detail and entire work),
1538

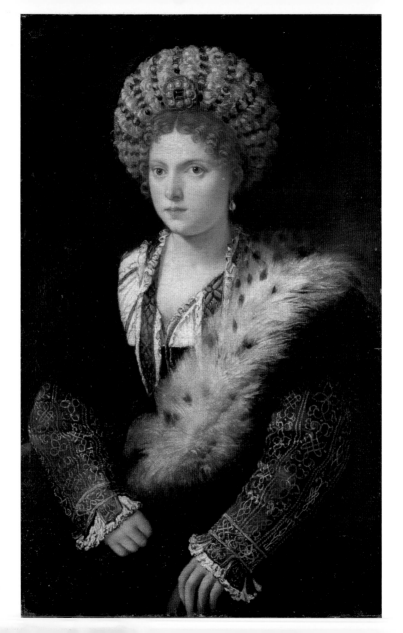

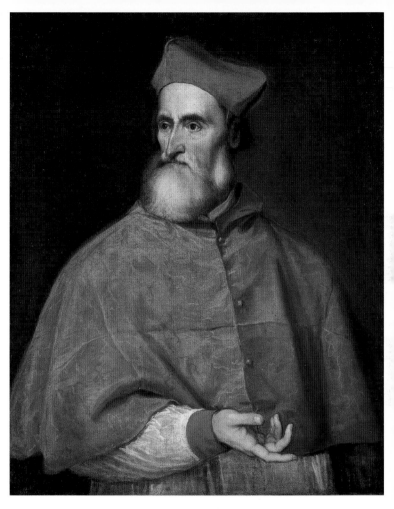

21. *Portrait of Isabella d'Este*, 1534–36

22. *Portrait of Cardinal Pietro Bembo*, 1539

Following pages
23. *Portrait of Ranuccio Farnese*, 1542

24. *Portrait of Pietro Aretino*, 1545

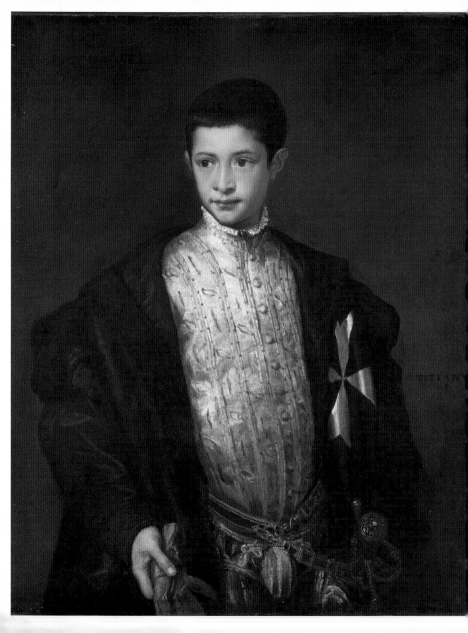

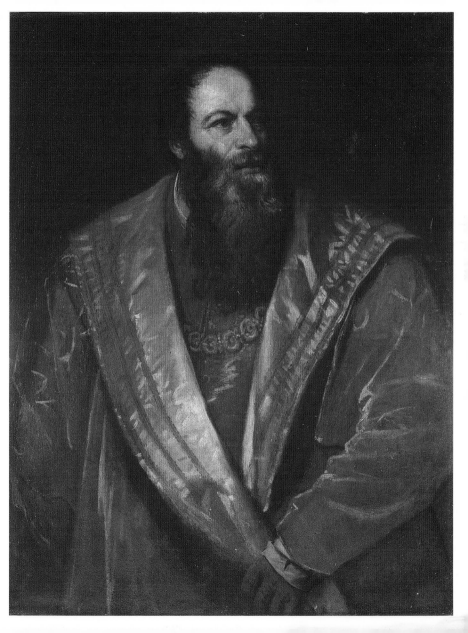

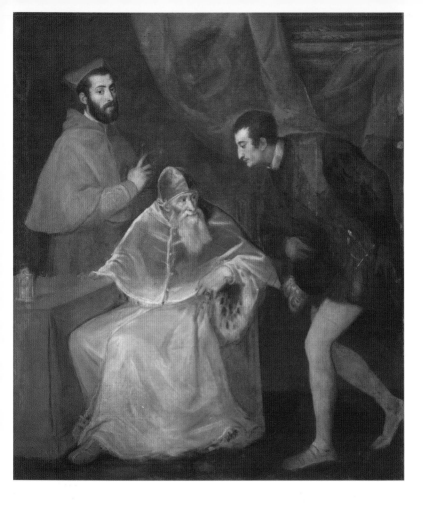

25. *Paul III and His Nephews Alessandro and Ottavio Farnese*, 1546

26. *Doge Andrea Gritti*, 1545–48

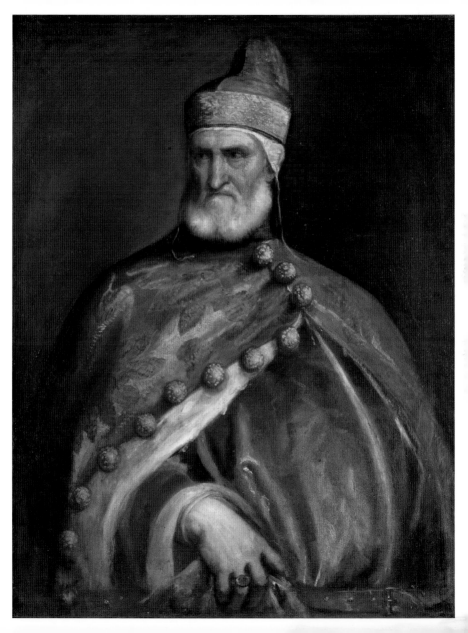

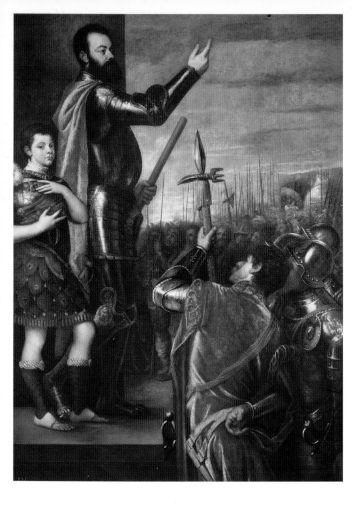

27. *The Marquis of Vasto Addressing his Troops*, 1540–41

28. *Portrait of Charles V on Horseback*, 1548

Following pages
29. *Saint John the Baptist*, circa 1540

30. *Pentecost*, circa 1546

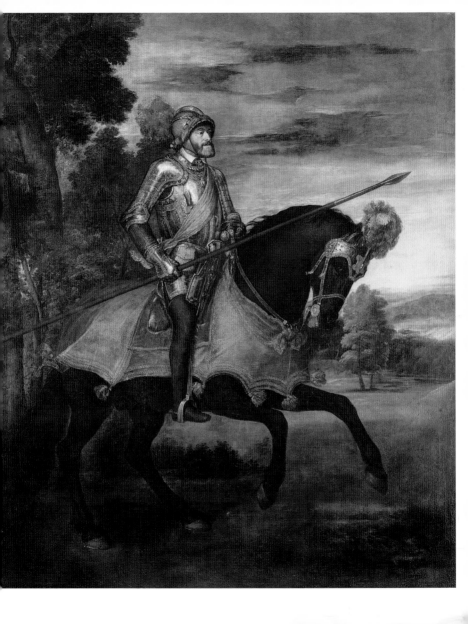

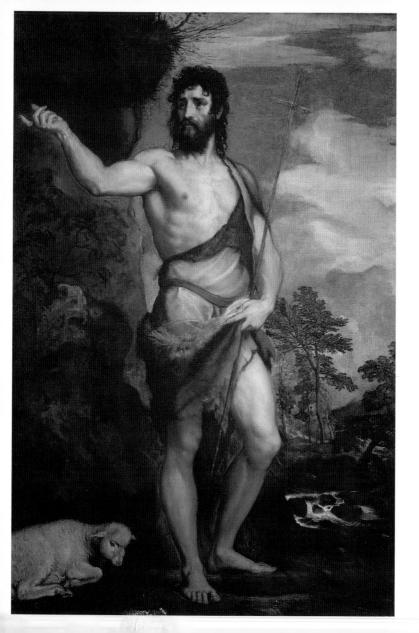

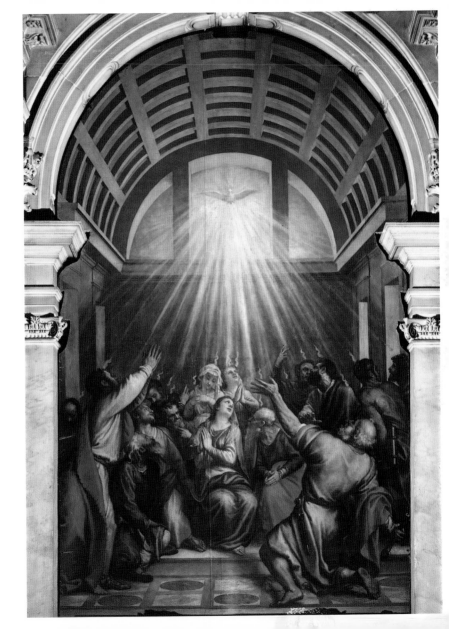

31. *The Vendramin Family,*
1543–47

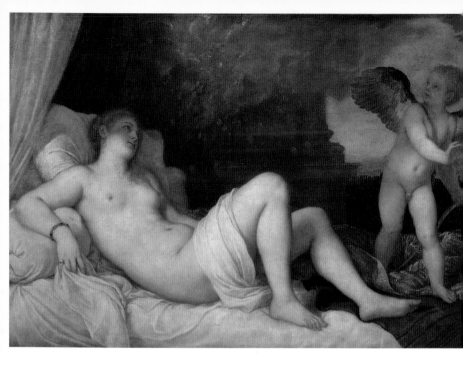

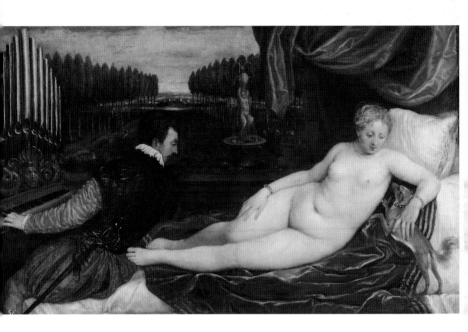

32. *Danae*, circa 1545

32. *Venus with the Organist*, 1550–51

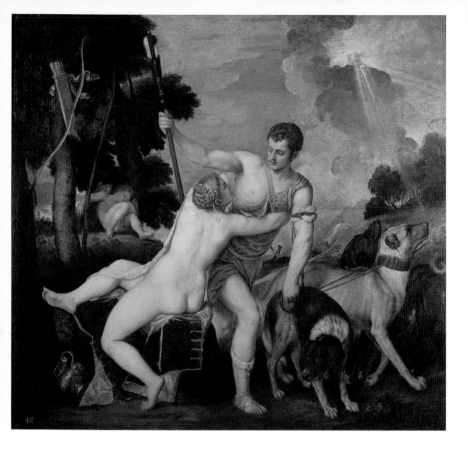

34. *Venus and Adonis,*
1553–54

35. *Venus with a Mirror,*
circa 1555

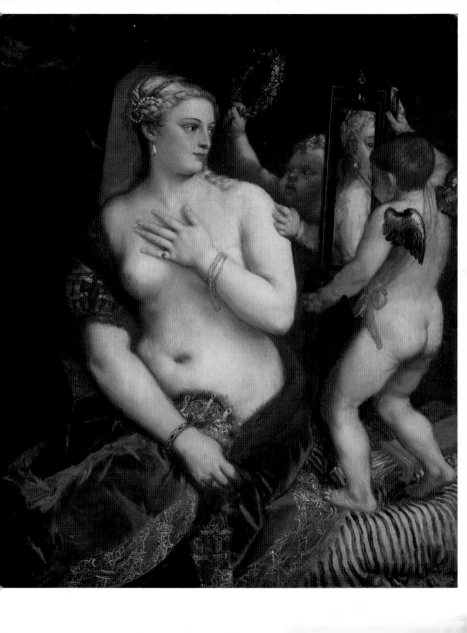

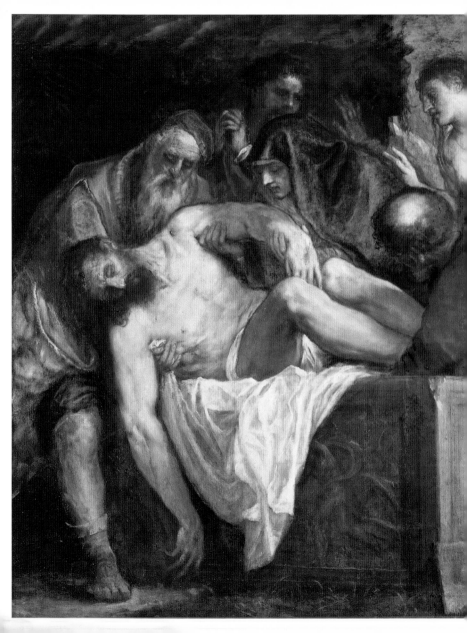

36. *Deposition*, 1559

Following pages
37. *Self-portrait, circa*
1562

38. *Portrait of Jacopo
Strada*, 1568

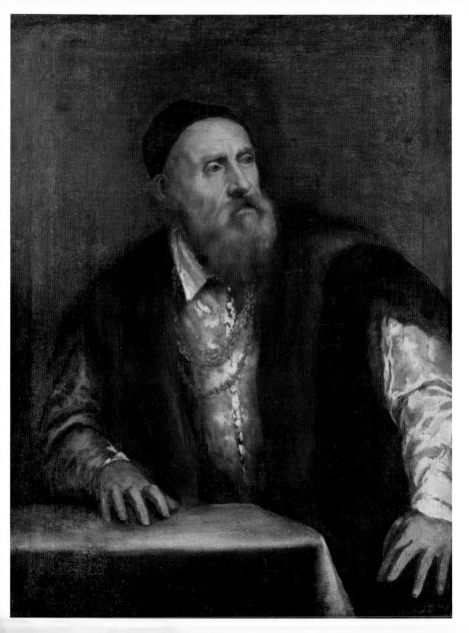

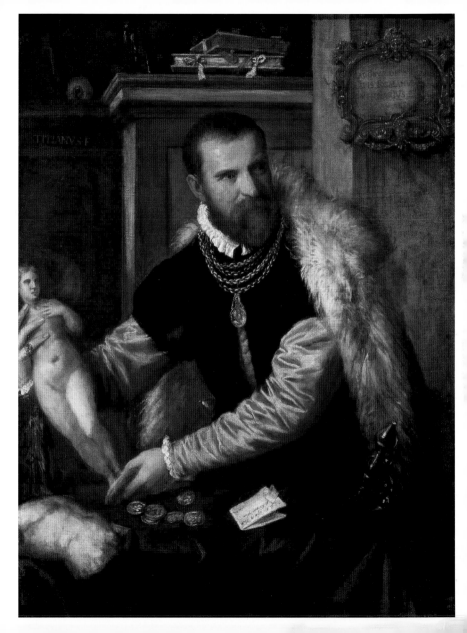

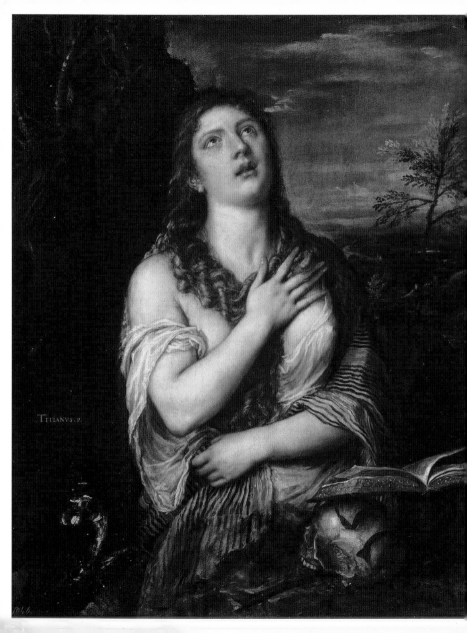

TITIANVS.P.

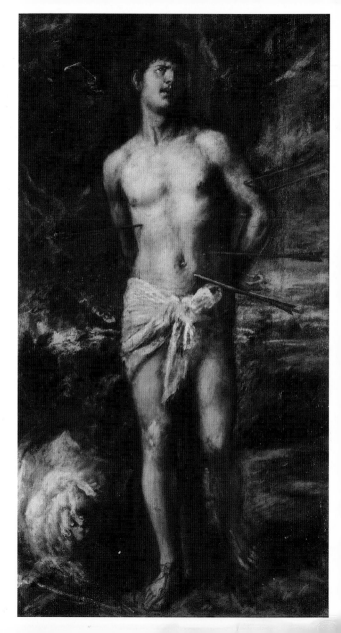

39. *Penitent Saint Mary Magdalene*, 1565

40. *Saint Sebastian,* circa 1570

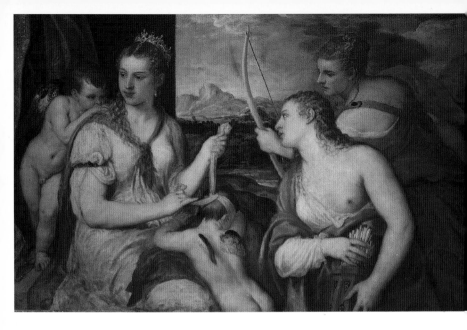

41. *Venus Blindfolding
Cupid, circa* 1565

42. *Religion Succoured
by Spain,* 1572–74

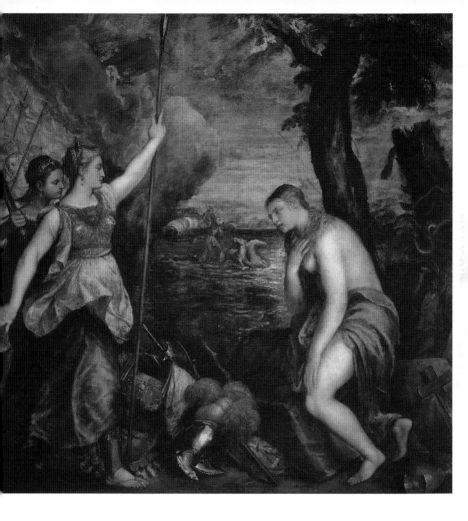

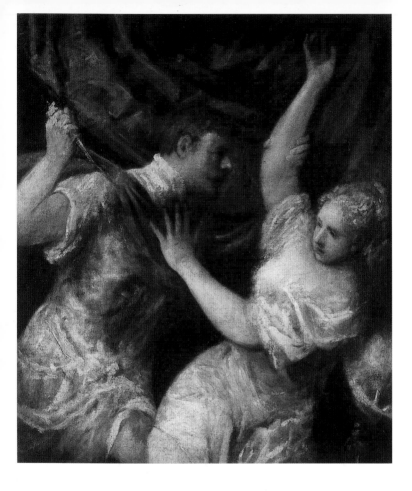

43. *Tarquin and Lucretia,*
circa 1570

44. *The Flaying of*
Marsyas, 1570–76

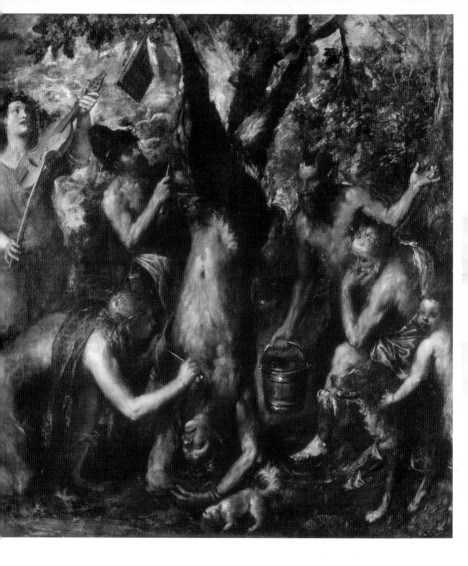

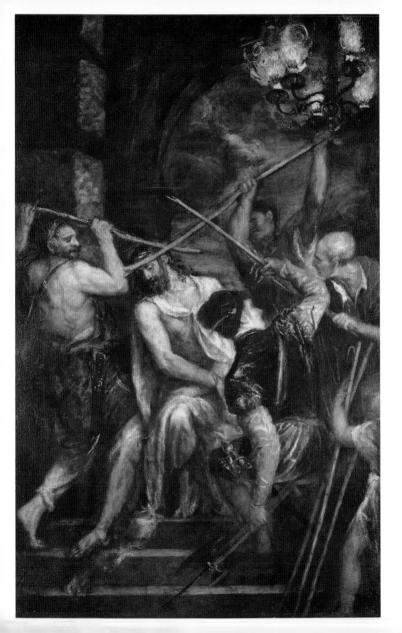

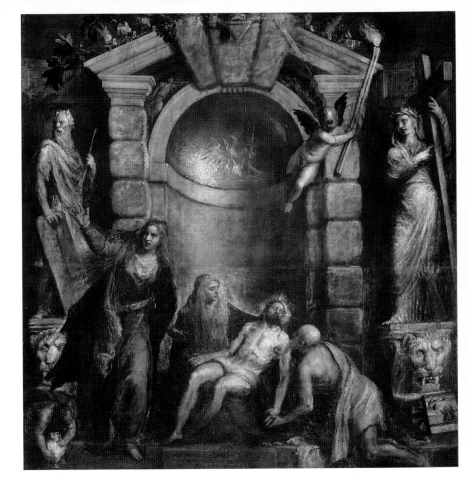

45. *Christc Crowned with Thorns, circa* 1570

46. *Pietà, circa* 1575

85

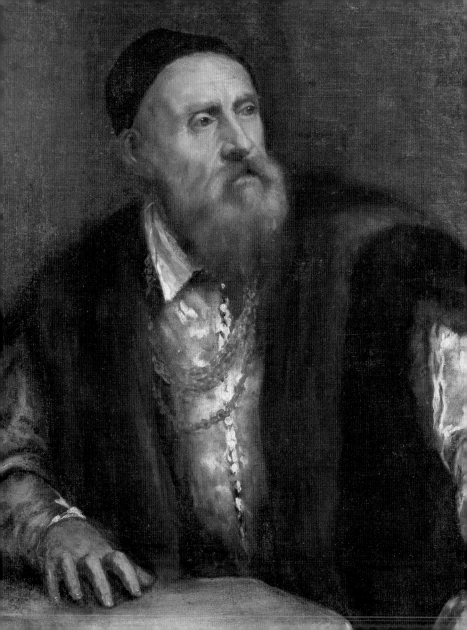

Appendix

Catalogue of the Works

1. *The Concert*, 1507–08
Oil on canvas, 86.5 x 123.5 cm
Galleria Palatina, Palazzo Pitti,
Florence

2. *Pope Alexander VI
Presenting Jacopo Pesaro
to Saint Peter*, 1503–06
Oil on canvas, 145 x 183 cm
Koninklijk Museum voor
Schone Kunsten, Antwerp

3. *Saint Mark Enthroned with
Saints Cosmas, Damian, Rock
and Sebastian*, 1510
Oil on wood, 218 x 149 cm
Santa Maria della Salute,
Venice

4. *The Miracle of the Jealous
Husband*, 1511
Fresco
Scuola del Santo, Padua

5. *The Miracle of the Healed
Foot*, 1511
Fresco
Scuola del Santo, Padua

6. *The Pastoral Concert*,
1509–10
Oil on canvas, 110 x 138 cm
Musée du Louvre, Paris

7. *The Three Ages of Man*,
1512–13
Oil on canvas, 90 x 150.7 cm
National Gallery of Scotland,
Edinburgh

8. *Sacred and Profane Love*,
1514–15
Oil on canvas, 118 x 278 cm
Galleria Borghese, Rome

9. *Flora, circa* 1515
Oil on canvas, 79.7 x 63.5 cm
Galleria degli Uffizi, Florence

10. *Assumption of the Virgin*,
1516–18
Oil on wood, 690 x 360 cm
Santa Maria Gloriosa dei Frari,
Venice

11. *Pesaro Altarpiece*,
1518–26
Oil on canvas, 478 x 266.5 cm
Santa Maria Gloriosa dei Frari,
Venice

12. *Portrait of a Gentleman
(Tommaso or Vincenzo Mosti)*,
1520 (?)
Oil on canvas, 85 x 67 cm
Galleria Palatina, Palazzo Pitti,
Florence

13. *Man with a Glove*,
1520–23
Oil on canvas, 100 x 89 cm
Musée du Louvre, Paris

14. *Bacchus and Ariadne*,
1522–23
Oil on canvas, 175 x 190 cm
The National Gallery, London

15. *Bacchanal on Andros*,
1523–24
Oil on canvas, 175 x 193 cm
Museo Nacional del Prado,
Madrid

16. *Averoldi Polyptych*,
1520–22
Oil on wood, 278 x 122 cm,
170 x 65 cm, 170 x 65 cm,
79 x 85 cm, 79 x 85 cm
Santi Nazzaro e Celso, Brescia

17. *Presentation of the Virgin
in the Temple*, 1534–38
Oil on canvas, 335 x 775 cm
Gallerie dell'Accademia, Venice

18. *Portrait of Francesco
Maria della Rovere*, 1536–37
Oil on canvas, 114 x 103 cm
Galleria degli Uffizi, Florence

19. *Portrait of Eleonora
Gonzaga della Rovere*,
1536–37
Oil on canvas, 114 x 103 cm
Galleria degli Uffizi, Florence

20. *Venus of Urbino*, 1538
Oil on canvas, 119 x 165 cm
Galleria degli Uffizi, Florence

21. *Portrait of Isabella d'Este*,
1534–36
Oil on canvas, 102 x 64 cm
Kunsthistorisches Museum,
Vienna

22. *Portrait of Cardinal Pietro
Bembo*, 1539
Oil on canvas, 94.5 x 76.5 cm
National Gallery, Washington

23. *Portrait of Ranuccio
Farnese*, 1542
Oil on canvas, 89.7 x 73.6 cm
National Gallery, Washington

24. *Portrait of Pietro Aretino*,
1545
Oil on canvas, 96.7 x 76.6 cm
Galleria Palatina, Palazzo Pitti,
Florence

25. *Paul III and His Nephews Alessandro and Ottavio Farnese*, 1546
Oil on canvas, 210 x 174 cm
Museo e Gallerie Nazionali di Capodimonte, Naples

26. *Doge Andrea Gritti*, 1545–48
Oil on canvas,
133.6 x 103.2 cm
National Gallery, Washington

27. *The Marquis of Vasto Addressing his Troops*, 1540–41
Oil on canvas, 223 x 165 cm
Museo Nacional del Prado, Madrid

28. *Portrait of Charles V on Horseback*, 1548
Oil on canvas, 322 x 279 cm
Museo Nacional del Prado, Madrid

29. *Saint John the Baptist*, circa 1540
Oil on canvas, 201 x 134 cm
Gallerie dell'Accademia, Venice

30. *Pentecost*, circa 1546
Oil on arched canvas,
570 x 260 cm
Santa Maria della Salute, Venice

31. *The Vendramin Family*, 1543–47
Oil on canvas, 206 x 301 cm
The National Gallery, London

32. *Danae*, circa 1545
Oil on canvas, 120 x 172 cm
Museo e Gallerie Nazionali di Capodimonte, Naples

33. *Venus with the Organist*, 1550–51
Oil on canvas, 136 x 220 cm
Museo Nacional del Prado, Madrid

34. *Venus and Adonis*, 1553–54
Oil on canvas, 136 x 220 cm
Museo Nacional del Prado, Madrid

35. *Venus with a Mirror*, circa 1555
Oil on canvas,
124.5 x 104.1 cm
National Gallery, Washington

36. *Deposition*, 1559
Oil on canvas, 130 x 168 cm
Museo Nacional del Prado, Madrid

37. *Self-portrait*, circa 1562
Oil on canvas, 96 x 75 cm
Staatliche Museen zu Berlin, Gemäldegalerie, Berlin

38. *Portrait of Jacopo Strada*, 1568
Oil on canvas, 125 x 95 cm
Kunsthistorisches Museum, Vienna

39. *Penitent Saint Mary Magdalene*, 1565
Oil on canvas, 118 x 97 cm
The State Hermitage Museum, Saint Petersburg

40. *Saint Sebastian*, circa 1570
Oil on canvas, 210 x 115.5 cm
The State Hermitage Museum, Saint Petersburg

41. *Venus Blindfolding Cupid*, circa 1565
Oil on canvas, 118 x 185 cm
Galleria Borghese, Rome

42. *Religion Succoured by Spain*, 1572–74
Oil on canvas, 168 x 168 cm
Museo Nacional del Prado, Madrid

43. *Tarquin and Lucretia*, circa 1570
Oil on canvas, 114 x 100 cm
Gemäldegalerie der Akademie der Bildenden Künste, Vienna

44. *The Flaying of Marsyas*, 1570–76
Oil on canvas, 212 x 207 cm
Archbishop's Palace, Kroměříž

45. *Christ Crowned with Thorns*, circa 1570
Oil on canvas, 280 x 181 cm
Alte Pinakothek, Munich

46. *Pietà*, circa 1575
Oil on canvas, 378 x 347 cm
Gallerie dell'Accademia, Venice

Life of Titian	Historical events
1480-85 Titian is born in Pieve di Cadore.	
1502	The allied Spanish, Venetian and pontifical fleets defeat the Turks at Santa Maura.
1503 Titian starts to paint the Antwerp altarpiece commissioned by Jacopo Pesaro.	Venice stipulates a peace treaty with the Turks.
1508 He paints the frescoes on the façade of the Fondaco dei Tedeschi.	The League of Cambrai is established against the Republic of Venice.
1511 The artist completes the three frescoes for the Scuola di Sant'Antonio in Padua.	
1513 Invited by Pietro Bembo to the pontifical court in Rome, Titian instead chooses to offer his services to the Republic of Saint Mark.	Julius II dies and is succeeded by Leo X, originally Giovanni de' Medici; Pietro Bembo is appointed pontifical secretary.
1516 From 31 January to 22 March Titian is in Ferrara as the guest of the court of Alfonso I d'Este. He is commissioned to paint the *Assumption of the Virgin* for Santa Maria Gloriosa dei Frari.	The Venetian army reconquers Brescia; Giovanni Bellini dies on 29 November.
1517 He is appointed to the Senseria of the Fondaco dei Tedeschi, vacated upon the death of Bellini.	Martin Luther affixes his Ninety-five Theses to the door of the Wittenberg cathedral.
1518 The *Assumption* of Santa Maria Gloriosa dei Frari is inaugurated on 19 May. In the meantime, Titian works on the paintings for the Alabaster Chamber of the Duke of Ferrara.	Jacopo Robusti, called Tintoretto, is born in Venice.
1519 Jacopo Pesaro commissions a painting for the altar of the Immaculate Conception in the church of Santa Maria dei Gloriosa dei Frari.	Emperor Maximilian I dies and is succeeded by Charles V, who unites the Spanish kingdom with the Habsburg Empire.
1523 He is in contact with Federico II Gonzaga; in Venice he is commissioned by Doge Gritti to fresco a chapel in the Doge's Palace.	Upon the death of Antonio Grimani, Andrea Gritti is elected doge.
1527 He offers two portraits to Federico II Gonzaga.	The lansquenets sack Rome.
1530 Titian is called to Bologna to paint a portrait of Charles V in armour for the emperor's coronation.	Pope Clement VI crowns Charles V king of Italy and emperor of the Holy Roman Empire.

Life of Titian	Historical events
1533 He again portrays Charles V in Bologna; upon his return to Spain, the emperor appoints Titian to high offices and grants him the honour of knighthood.	
1538 Titian works on the *Venus of Urbino* for Duke Guidobaldo II della Rovere; he paints a portrait of the king of France, Francis I, after a medal by Benvenuto Cellini.	The Turks defeat the Holy League at Preveza.
1540 He paints *Christ Crowned with Thorns* for the church of Santa Maria delle Grazie.	
1541 Titian delivers *The Marquis of Vasto Addressing his Troops* to the commander portrayed in the painting; he completes the first version of the *Pentecost*.	Giorgio Vasari arrives in Venice.
1542 He paints the portrait of Ranuccio Farnese and the works for Santo Spirito in Isola.	Lorenzo Lotto paints *The Alms of Saint Anthony*.
1545 On 9 October Titian is welcomed to the pontifical court. He paints the *Danae* for Cardinal Alessandro Farnese.	The Council opens in Trent, ending in 1563.
1548 Titian travels to Augusta and paints numerous portraits, including one of Charles V on horseback.	Tintoretto paints *The Miracle of Saint Mark*.
1550 Invited by Philip II, he returns to Augusta and produces numerous paintings for the sovereign.	The first edition of Vasari's *Lives of the Artists* is published.
1564 Titian sends Philip II the *Last Supper*, commenced in 1558.	Tintoretto starts work to decorate the Scuola Grande di San Rocco.
1573 Titian paints the canvas of *Philip II Offering Don Fernando to Victory*, celebrating the victory at Lepanto.	On 7 March Venice stipulates a separate peace with the Turks, ceding Cyprus.
1576 Titian dies on 27 August and is buried in the church of Santa Maria Gloriosa dei Frari.	

Critical Anthology

G. Vasari
The Lives of the Artists, 1568
Titian was a very healthy man and was as fortunate as any other artisan of his kind has ever been, for he has received nothing from the heavens but favour and felicity. His home in Venice has been visited by a great many princes, men of letters, and nobleman who, in his time, have gone to pass some time in Venice, because, besides being an excellent artisan, Titian was very kind an well-bred, being possessed of the gentlest habits and manners. He had many rivals in Venice, but none of great worth, and he easily surpassed them through the excellence of his art and his ability to deal with and to make himself pleasing to the nobility; he earned a great deal, because his works were always well paid for, but he would have done well in his last years not to have worked except as a pastime to avoid damaging with less skilful works the reputation earned in his best years before his natural gifts had begun to decline. (…) Thus Titian, who has decorated Venice, or rather all of Italy and other parts of the world, with superb paintings, deserves to be loved and respected by all artisan and in many ways to be admired and imitated, like those other artisans who have produced and still are producing works worthy of boundless praise, which will endure as long as the memory of illustrious men. Although a large number of artisans studied with Titian, not many of them can truly be called his followers, for he did not teach much, but each one of then learned more or less, according to what they knew how to take from the works Titian executed.

C. Ridolfi
The life of Titian, 1648
At the precise moment Giorgione was displaying the beauties of his talent, and everyone believed the art of painting had re-established its hopes and, with the greatest praise, regained its former honours, Titian, to everyone's astonishment, attracted the admiring gaze of all. And although the world thought Giorgione had achieved the ultimate aim of art, he had completed only a few paintings in the brief years of his life, and a still greater inventiveness remained to be seen, along with somewhat more delicacy, and a broad unfolding of things, all of which were the accomplishments of the distinguished hand of Titian, to the degree that all the most rare marvels of painting were seen gathered together in the work of this celebrated man.

W. Goethe
Italian Journey, 1786–87
My tendency to look at the world through the eyes of the painter whose pictures I have seen last has given me an odd idea. Since our eyes are educated from childhood on by objects we see around us, a Venetian painter is bound to see the world as a brighter and gayer place than most people see it. We northerners who spend our lives in a drab and, because of the dirt and the dust, an uglier country where even reflected light is subdued, and who have, most of us, to live in cramped rooms – we cannot instinctively develop an eye which looks with such delight at the world. As I glided over the lagoons in the brilliant sunshine and saw the gondoliers in their colourful costumes,

gracefully posed against the blue sky as they rowed with easy strokes across the light-green surface of the water, I felt I was looking at the latest and best painting of the Venetian school. The sunshine raised the local colours to a dazzling glare and even the parts in shadow were so light that they could have served pretty well as sources of light. The same could be said of the reflections in the water. Everything was painted clearly on a clear background. It only needed the sparkle of a white-crested wave to put the dot on the i. Both Titian and Veronese possessed this clarity to the highest degree, and when we do not find it in their work, this means that the picture has suffered damage or has been retouched.

B. Berenson

The Venetian Painters of the Renaissance, 1894

Titian's real greatness consists in the fact that he was as able to produce an effect of greater reality as he was ready to appreciate the need of a firmer hold on life. In painting, as I have said, a greater effect of reality is chiefly a matter of light and shadow, to be obtained only by considering the canvas as an enclosed space, filled with light and air, through which the objects are seen. There is more than one way of getting this effect, but Titian attains it by the almost total suppression of outlines, by the harmonising of his colours, and by the largeness and vigour of his brushwork. In fact, the old Titian was, in his way of painting, remarkably like some of the best French masters of to-day. This makes him only the more attractive, particularly when with handling of this kind he combined the power of creating forms of beauty such as he has given us in the *Wisdom* of the Venetian Royal Palace, or in the *Shepherd*

and Nymph of Vienna. The difference between the old Titian, author of these works, and the young Titian, painter of the *Assumption*, and of the *Bacchus and Ariadne*, is the difference between the Shakspeare of the *Midsummer-Night's Dream* and the Shakspeare of the *Tempest*. Titian and Shakspeare begin and end so much in the same way by no mere accident. They were both products of the Renaissance, they underwent similar changes, and each was the highest and completest expression of his own age. (…) I have dwelt so long on Titian, because, historically considered, he is the only painter who expressed nearly all of the Renaissance that could find expression in painting.

L. Freedman

Titian's Portraits Through Aretino's Lens, 1995

Although it was Aretino who originally applied the phrase "Pittore Divino" to Titian, it was Dolce who explained this appellation, even if only by implication, in his *Dialogo*, using Aretino as the main spokesman of the principles of Venetian art as embodied by Titian. "[Painters] surpass the rest of humanity in intellect and spirit, doing as they do to imitate with their art the things which God has created, and to put the latter before us in such a way that they appear real", Dolce had Aretino declare. (…) Indeed Dolce reverted more than once in his dialogue to Titian's miraculous ability to represent the subjects in his paintings in such a way that "every one of his figures had life, movement and flesh which palpitates". Titian's portraits "are of such great excellence", Dolce said, "that there is no more life in the life itself". He ended his dialogue with the statement that "our own Titian, therefore, is divine and without

equal in the realm of painting; nor should Apelles himself refuse to do him honour, supposing he were alive". Thus, according to Dolce, the divinity of Titian's art lay in his ability to capture his subjects on canvas so realistically that they seem alive, that they seem to have been born anew under the artist's hand. The resemblance seems even to surpass the prototype, for the paintings enjoy a longer life than their human subjects.

D.A. Brown

Disharmony in the 'Concert', Art News, June 2006

Contemporaries, we are told, could not easily distinguish Titian's early works from the works of Giorgione, so thoroughly had the younger artist assimilated his mentor's style. Titian's *Pastoral Concert* is the most Giorgionesque of all his paintings and was once attributed to Giorgione. At the center of a lush pastoral landscape, two young men, a sumptuously dressed patrician playing a lute and a humble shepherd, exchange glances. They ignore – or fail to see – the nude females, probably classical nymphs, who accompany them. Shortly after completing *Pastoral Concert*, Titian painted a second version of a musical theme, *Concert* (1511–12), now in the Palazzo Pitti, Florence. This painting, too, was formerly attributed to Giorgione, largely because of the fashionably dressed young man on the left. It belongs to a new type of quasi-narrative composition invented by Giorgione, in which two or more figures, apparently portraits, are shown half-length in an oblong format. In the Pitti picture, the central figure abruptly turns from playing a keyboard instrument to cast a rapturous gaze at a tonsured cleric holding a viola da gamba. While its exact meaning has not been established, the Pitti painting seems to represent a symbolic turning point in the life of the protagonist, who literally turns away from his companion toward the older figure, interrupting the performance.

Looking out at the viewer as if to underscore what is happening in the picture, the youth on the left is a Giorgionesque type like the urbane lute player in *Pastoral Concert*. His plumed hat further identifies him as a dandy, as in Dürer's engraving *The Promenade* (*circa* 1498). In Dürer's print, the figure of Death in the background reminds the young lovers of the vanity of luxury and worldly pleasures. Though Titian's *Concert* is not a *vanitas* or a *memento mori*, it similarly contrasts the self-indulgence of carefree youth with self-discipline and moral probity. What is most striking about the painting, perhaps, is the dichotomy between the two youthful figures. One is richly dressed and vapid; the other, more soberly attired and dynamic.

Neither *Concert* excludes the possibility of an intimate relationship between the young men depicted, but only the keyboard player in the Pitti picture is clearly a portrait. His figure shows Titian abandoning Giorgionesque poetry in favor of a newly realistic portraiture better suited to his own temperament and the needs of his clients. Titian contrasts the artificiality and inertia of the Giorgionesque type, as he saw it, with the realism and expressive force of the keyboard player, who seems to embody the artist's own vitality. In the context of the rivalry from which Titian had just emerged victorious, could the musician, while not a self-portrait, stand for the artist and his rejection of Giorgione's manner? Whatever the case, Giorgione's untimely death cleared the way for his protégé. After another scarcely less gifted artist, Sebastiano Luciani (later called del Piombo), left Venice for Rome in August 1511, only the near-80-year-old Bellini remained an obstacle to Titian's advancement.

Selected Bibliography

B. Berenson, *The Venetian Painters of the Renaissance*, New York–London 1894

C. Phillips, *The earlier Work of Titian*, London 1897

L. Hourticq, *La jeunesse de Titien*, Paris 1919

H. Tietze, *Tizian. Leben und Werk*, Vienna 1936

Th. Hetzer, *Tizian*, Frankfurt 1948

H. Tietze, *Tizian Gemälde und Zeichnungen*, Vienna 1950

F. Valcanover, *All the Paintings of Titian*, London 1965

C. Gould, *The studio of Alfonso d'Este and Titian's 'Bacchus and Ariadne': a re-examination of the chronology of the Bacchanals and the evolution of one of them*, London 1969

E. Panofsky, *Problems in Titian, mostly iconographic*, London 1969

E.H. Wethey, *The complete painting of Titian*, London 1969-1975

D. Rosand, *Titian*, New York 1978

T. Pignatti (edited by), *The Golden Century of Venetian Painting*, Los Angeles 1979

C. Hope, *Titian*, London 1980

J. Martineau, C. Hope (edited by), *The Genius of Venice 1500-1600*, London 1983

M. Laclotte (edited by), *Le siècle de Titien. L'âge d'or de la peinture à Venise*, exhibition catalogue, Paris 1993

F. Pedrocco, *Titian*, Florence–London 1993

L. Freedman, *Titian's Portraits Through Aretino's Lens*, Philadelphia 1995

R. Goffen (edited by), *Titian's Venus of Urbino*, New York–Cambridge 1997

R. Goffen, *Renaissance rivals: Michelangelo, Leonardo, Raphael, Titian*, New Haven–London 2002

D. Jaffé (edited by), *Titian: Catalogue of the National Gallery Exhibition 1 9 Feb-18 May 2003*, London 2003

C. Hope, *Titian*, London 2003

U.R. D'Elia, *The poetics of Titians religious paintings*, Cambridge 2005

D.A. Brown, *Bellini, Giorgione, Titian, and the Renaissance of Venetian Painting*, New Haven–London 2006

N. Spinosa, J. Fletcher (edited by), *Titien. Le Pouvoir en Face*, Milan 2006

N. Wolf, *I, Titian*, Munich–London 2006

P. Humfrey, *Titian*, London 2007

L. Silver, E. Wyckhoff (edited by), *Grand scale: Monumental prints in the age of Dürer and Titian*, exhibition catalogue, New Haven–London 2008

F. Ilchman (edited by), *Titian, Tintoretto, Veronese: rivals in Renaissance Venice*, Aldershot 2009